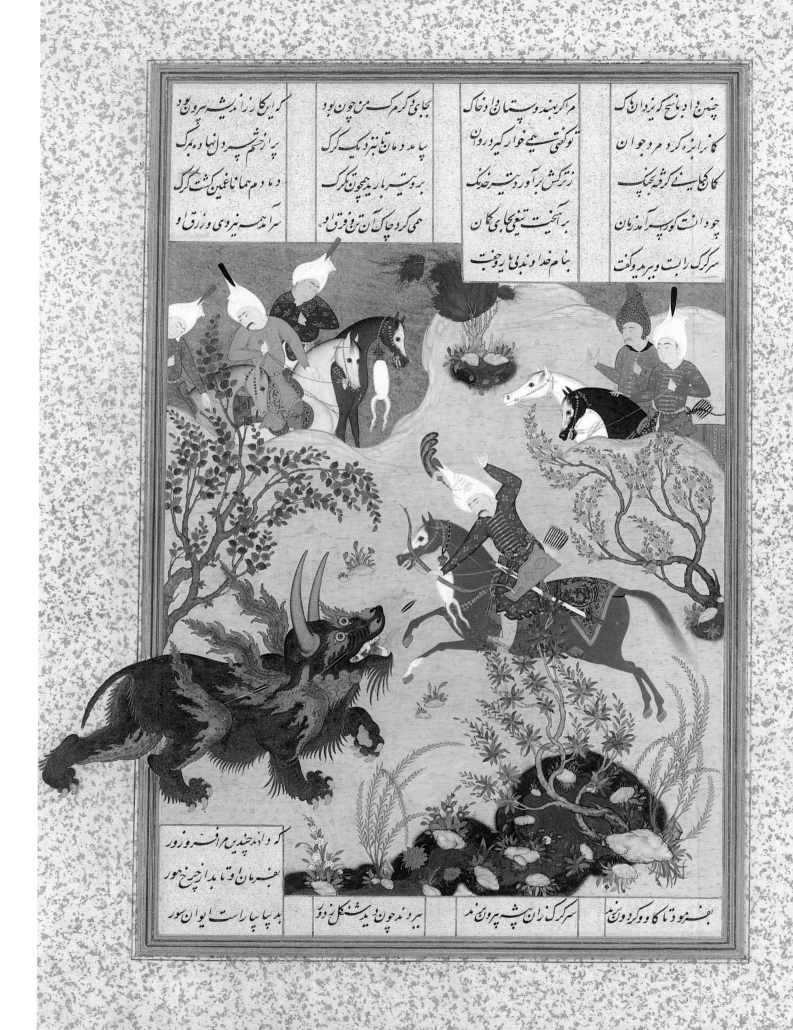

A CHILD'S BOOK OF

PLAY in ART

SELECTED BY LUCY MICKLETHWAIT

GREAT PICTURES
GREAT FUN

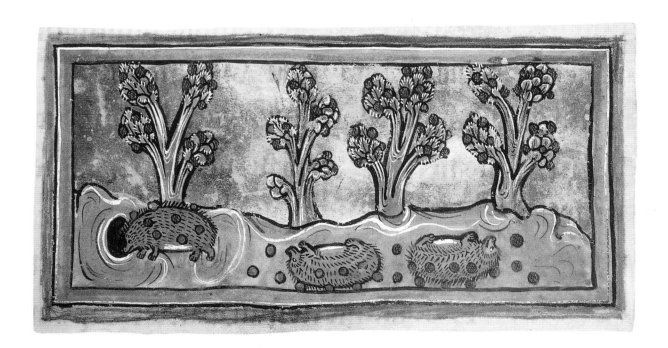

A DK PUBLISHING BOOK

*For my mother
and father*

Editor Rachel Harrison
Designer Sarah Thornton
Managing Editor Sheila Hanly
US Editor Camela Decaire
DTP Designer Nicola Studdart
Picture Researcher Jo Carlill
Production Louise Barratt

First American Edition, 1996
2 4 6 8 10 9 7 5 3 1

Published in the United States by
DK Publishing, Inc.
95 Madison Avenue, New York, NY 10016
http://www.dk.com

A CIP catalog record for this book is available
from the Library of Congress.

ISBN 0-7894-1003-6

Reproduced in Italy by G.R.B. Graphica, Verona
Printed and bound in Italy by Mondadori

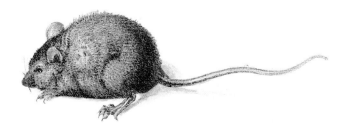

Contents

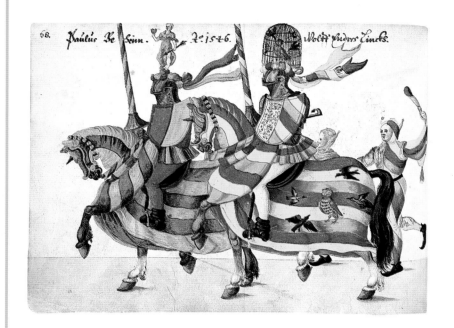

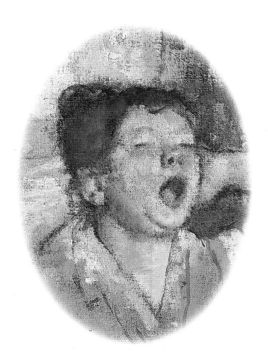

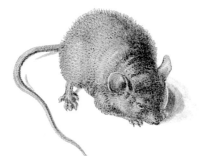

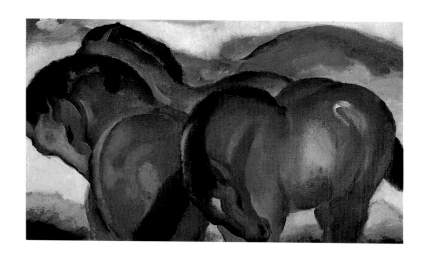

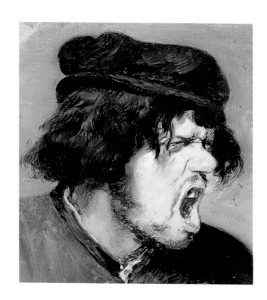

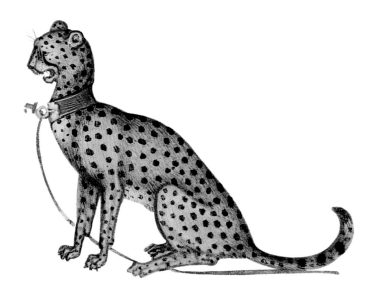

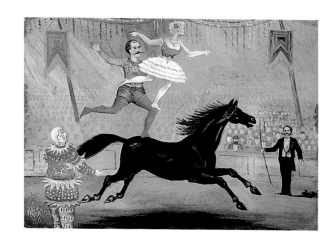

Note to Parents and Teachers

Introducing children to art is as easy as opening a book, and the rewards are enormous. For thousands of years people have expressed themselves through art, so there is much to see and a great deal to learn. By giving children just a few pictures, you can open up this world of infinite richness and diversity for them to explore.

As you look at these pictures with a child, talk about anything that springs to mind – the expression on a face, the pattern on a dress, or even the color of the sky. Talk about how a picture makes you both feel. Is it a happy picture or a sad one? Is it noisy or quiet? Imagine that you can climb right into the pictures together – rolling hoops in a playground scene or defending a castle under siege.

I have chosen pictures that will, I hope, inspire a wide range of activities. Children can pretend to be angry like the Japanese actor, or fast asleep like the princess. They can have fun dressing up as knights in armor, they can make animal noises, or copy the different faces.

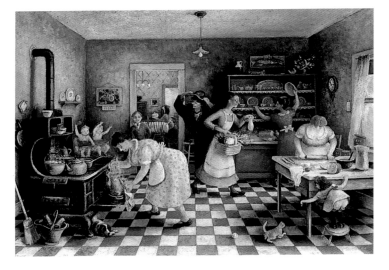

Quieter activities include matching games, which are fun and encourage close observation. Children can match cutout details to the pictures – a peacock from an animal painting, or a child skipping from a Japanese print – or try "Spot the Difference," comparing old and new versions of the same scene.

The paintings in this book offer endless opportunities for broadening a child's general knowledge. Point out different styles of architecture and clothing, talk about the Aztecs and the Greeks, or compare the tribal chief with the young Queen Elizabeth. Some paintings, such as those illustrating the five senses, can be used specifically to develop a child's vocabulary. Others can be used to develop the imagination – ask the child to imagine what people are thinking, or to make up a story about a favorite picture.

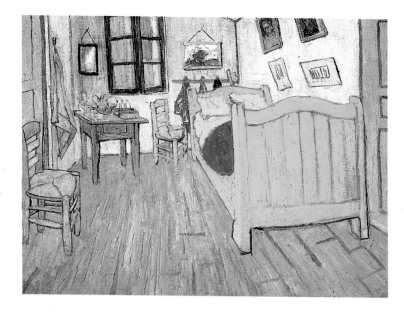

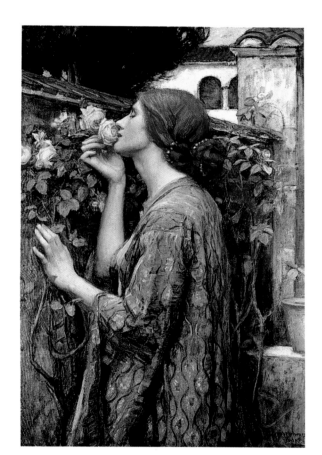

All artists are influenced and inspired by one another. Some children may enjoy copying a painting, tracing it and coloring it in. Others might rather paint their own funny-colored animals or inventions. Experimenting with patterns and designs is always fun. The aboriginal diamond design would work well with wax crayons and watercolors, and Klimt's patchwork cloak could inspire a lovely collage of colored paper and candy wrappers. All these activities are entertaining, and also help increase a child's understanding of art.

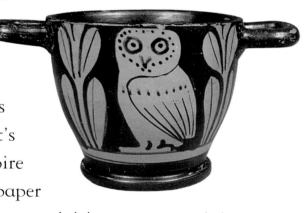

You do not need to be a teacher or an art historian to share a painting with a child. Children love exploring pictures and finding familiar and unfamiliar things in them. Let your child guide you through this book, and share the delight of discovering something new on every page.

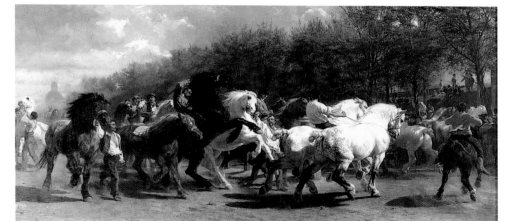

Let's Play

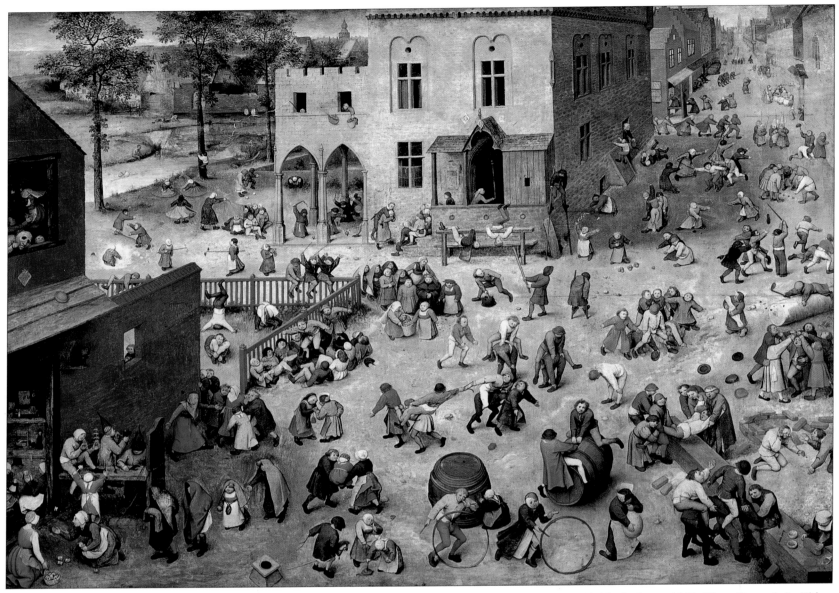

Children's Games, 1560, Pieter Bruegel the Elder

tug-of-war

leapfrog

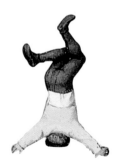

headstand

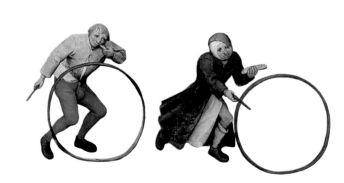

rolling hoops

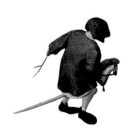

riding a
hobbyhorse

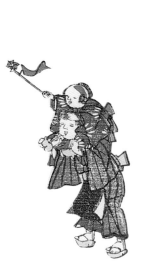

riding
piggyback

jumping
rope

flying
a kite

bouncing
a ball

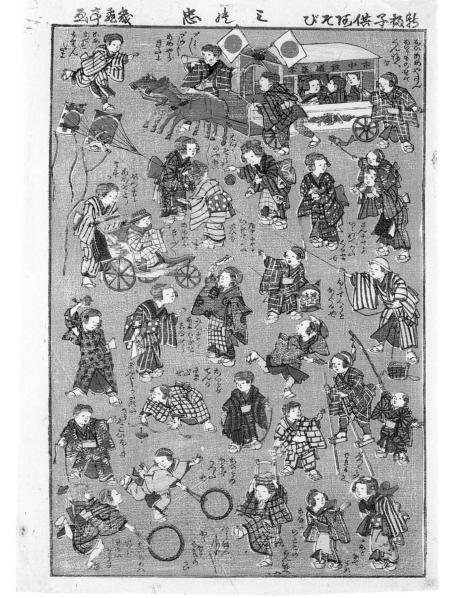

Children's Games, c.1868-1912, Japanese

spinning tops

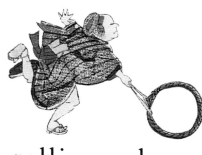

rolling a hoop

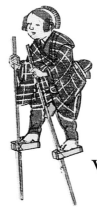

stilt
walking

All Dressed Up

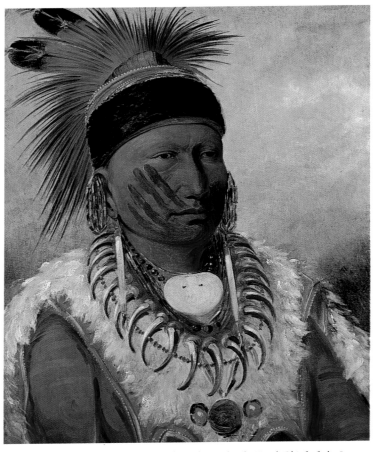

chief

The White Cloud, Head Chief of the Iowas,
1844/45, George Catlin

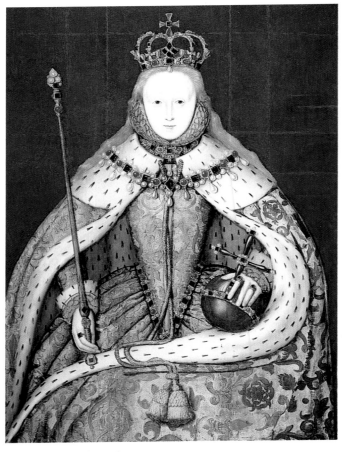

Elizabeth I, c.1569, unknown artist

queen

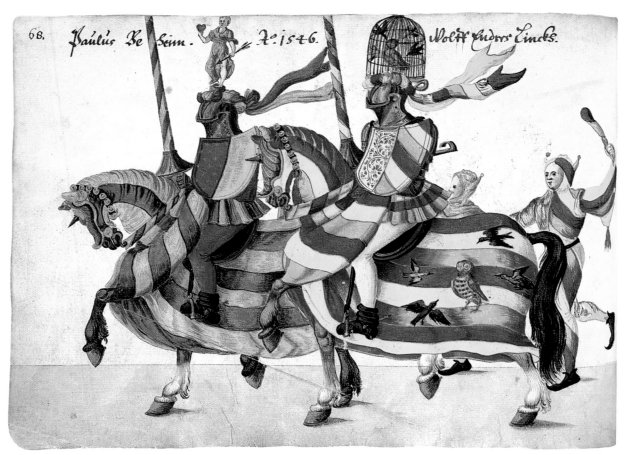

knights

Two Knights Armed for the Joust, after 1561,
from a German tournament book

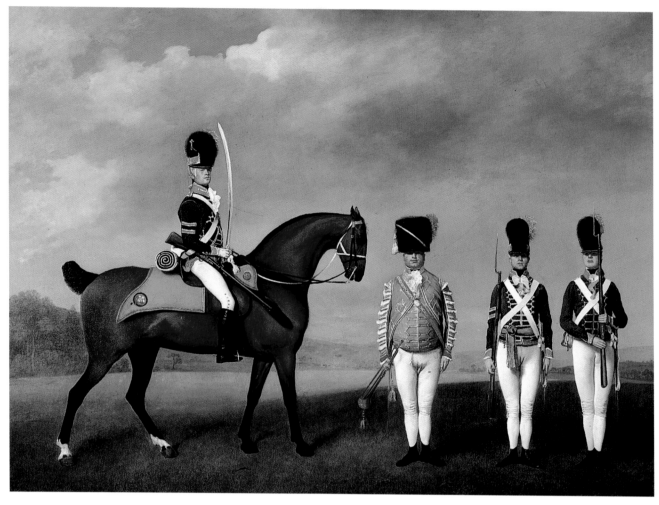

Soldiers of the Tenth Light Dragoons, 1793, George Stubbs

soldiers

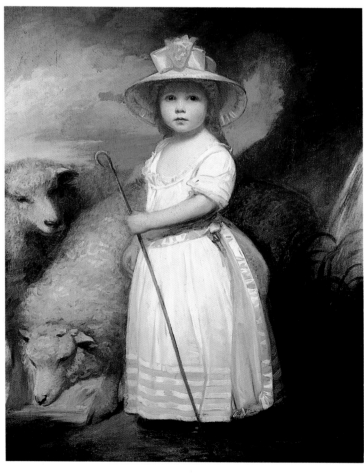

shepherdess

Shepherd Girl, c.1778,
George Romney

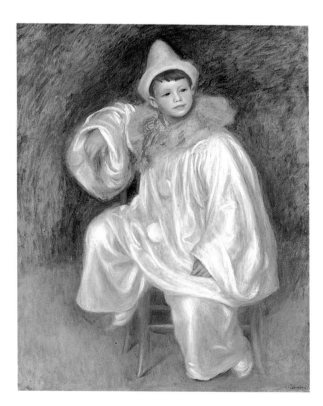

clown

The White Pierrot, 1905,
Auguste Renoir

Where Will We Live?

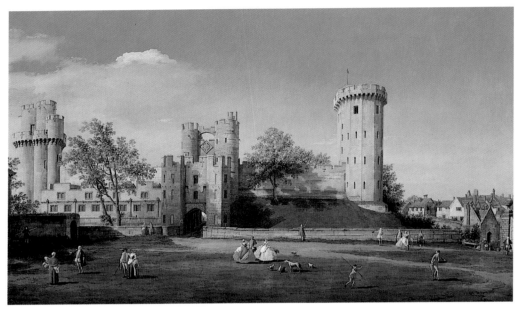

in a castle

Warwick Castle: The East Front, 1740s, Canaletto

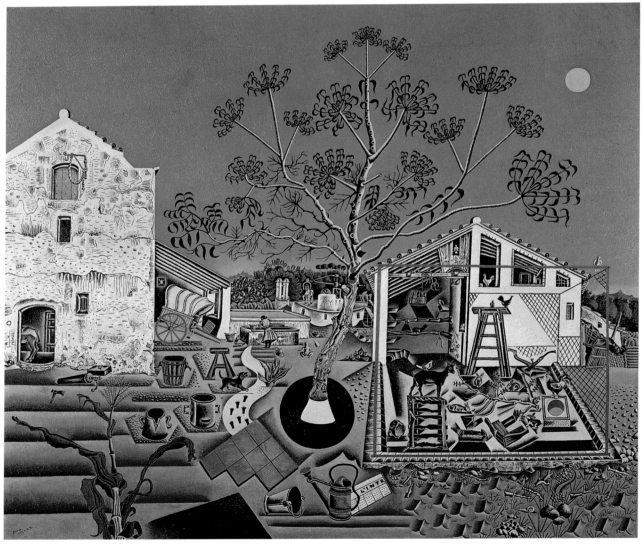

on a country farm

The Farm, 1921-22, Joan Miró

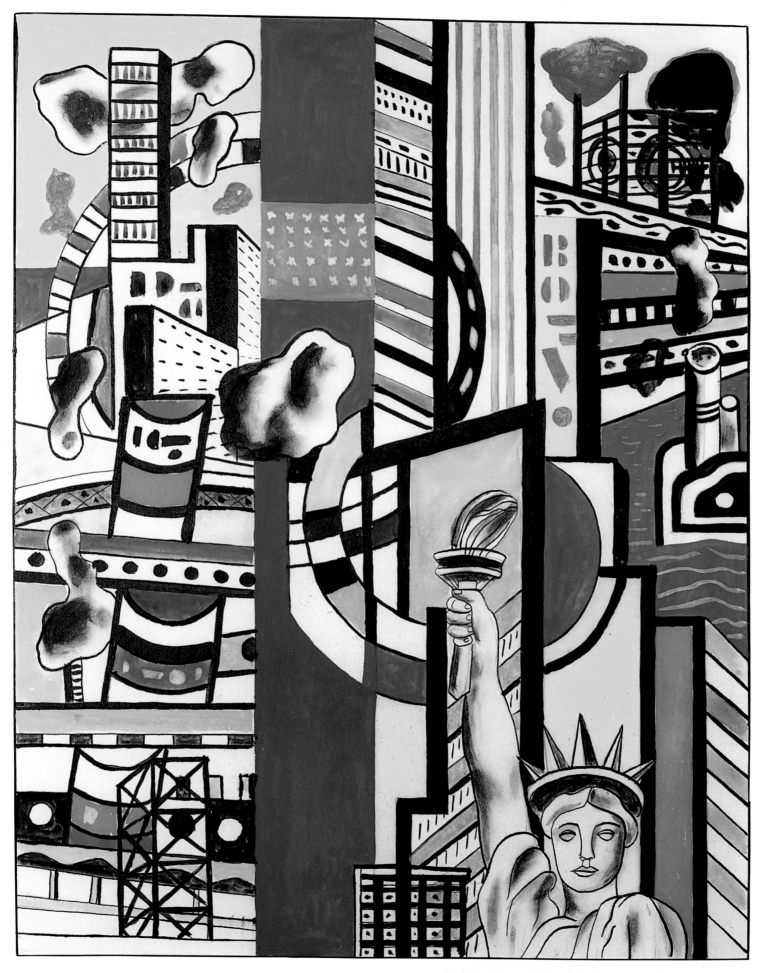

in a city apartment

Study for Cinematic Mural, Study I, 1939-40, Fernand Léger

Let's Pretend

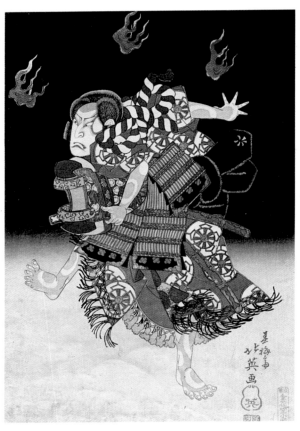

to get angry

The Kabuki Actor Nakamura Shikan II,
1835, Shunbaisai Hokuei

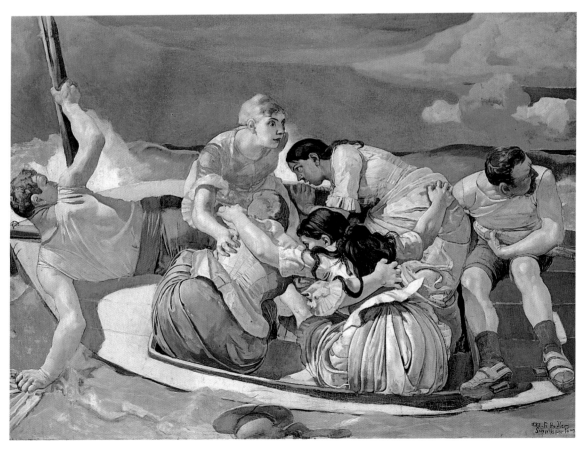

to be frightened

Surprised by the Storm, 1886, Ferdinand Hodler

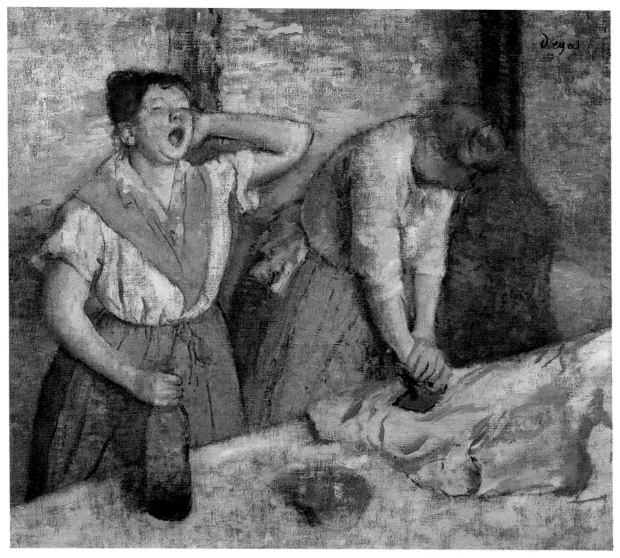

Women Ironing, c.1884, Edgar Degas

to feel tired

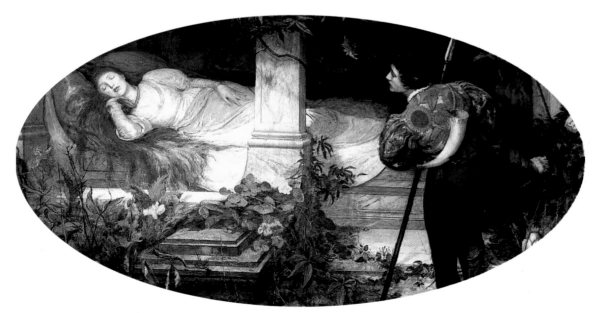

to fall asleep

Sleeping Beauty (detail), 19th century,
Edward Frederick Brewtnall

Make the Faces

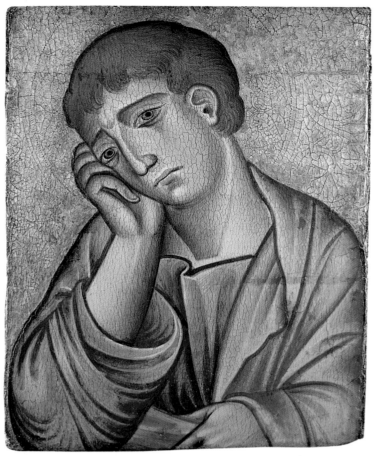

sad

St. John Mourning,
late 13th century, Circle of Cimabue

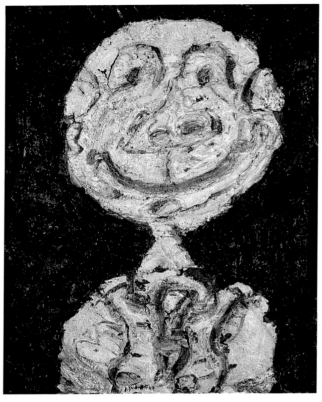

happy

Portrait of Francis Ponge – Hilarious Figure,
1947, Jean Dubuffet

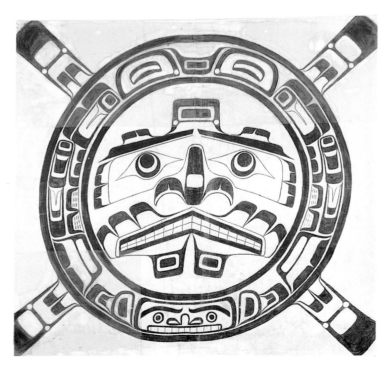

worried

A Kwakiutl Ceremonial Screen,
c.1935, Willie Seaweed

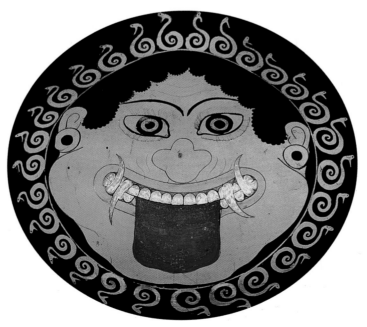

silly

Gorgon's Head, c.490 BC,
Greek vase painting

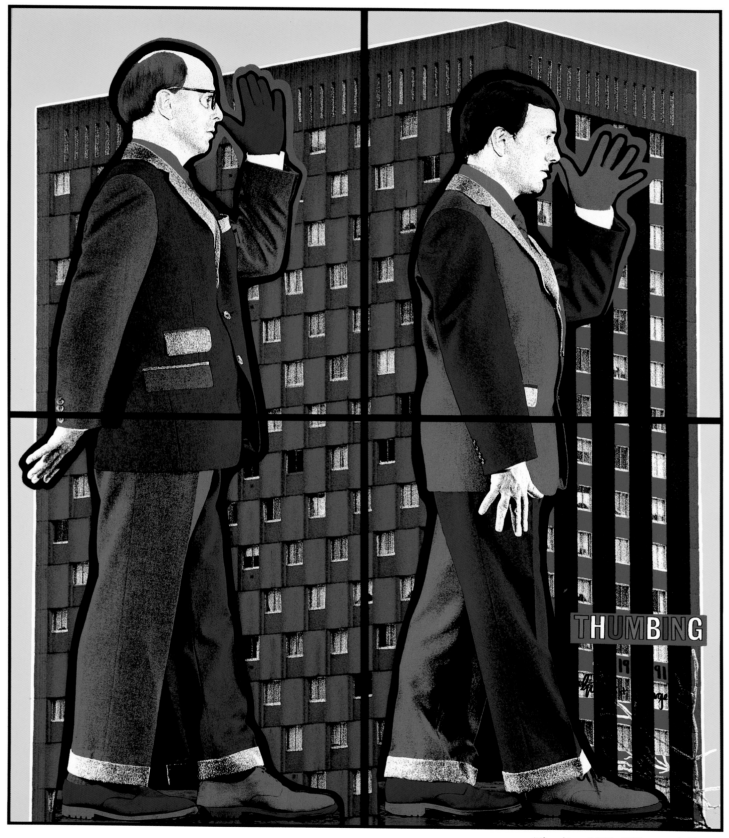

rude

Thumbing, 1991, Gilbert and George

Animal Noises

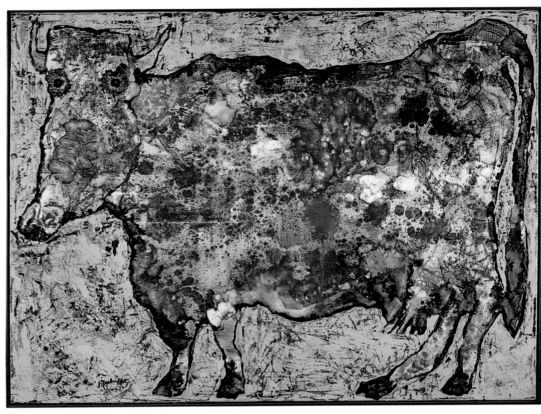

moo like
a cow

The Cow with the Subtile Nose, from the *Cows, Grass, Foliage* series, 1954, Jean Dubuffet

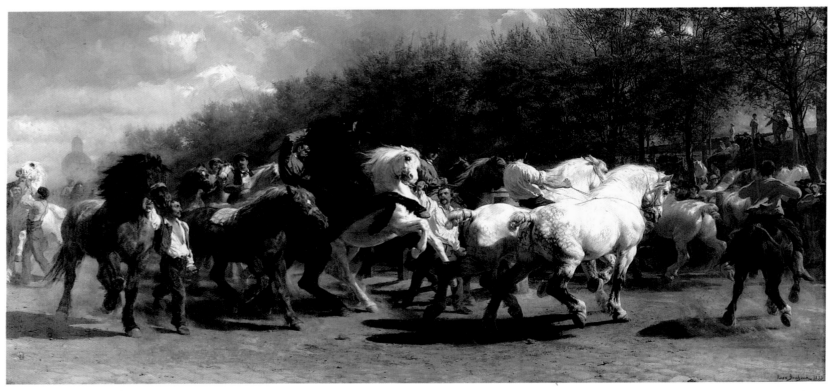

neigh like a horse

Horse Fair, 1853, Rosa Bonheur

growl like a tiger

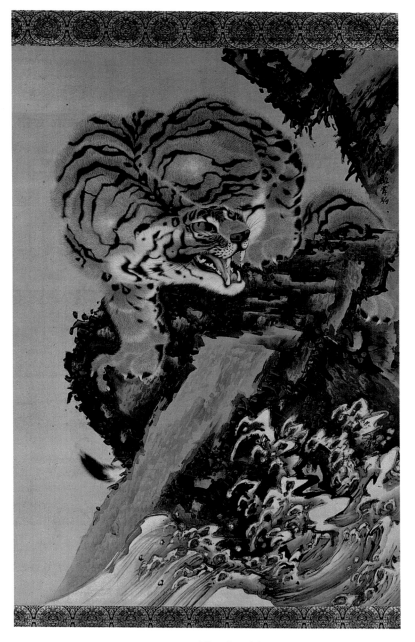

Tiger by a Torrent, c.1795, Kishi Ganku

hoot like an owl

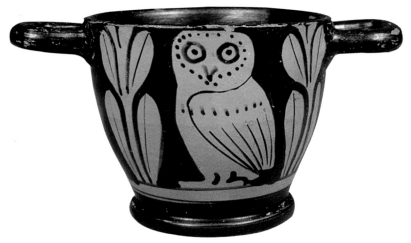

Drinking cup with owl between two olive twigs,
4th century BC, Greek

squeak like a mouse

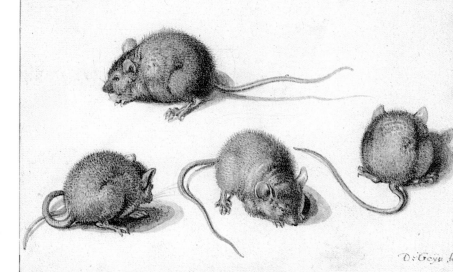

Fieldmice, c.1600, Jacob de Gheyn II

How Do They Smell?

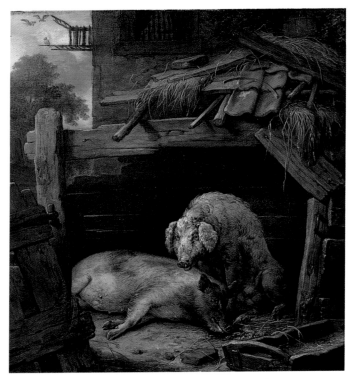

pigsty

The Pigsty, 1647,
Paulus Potter

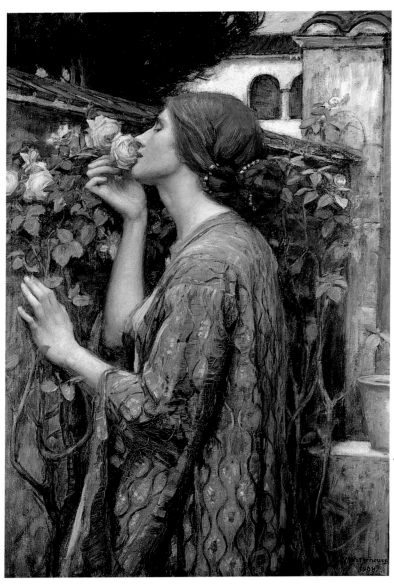

rose

The Soul of the Rose, 1908,
John William Waterhouse

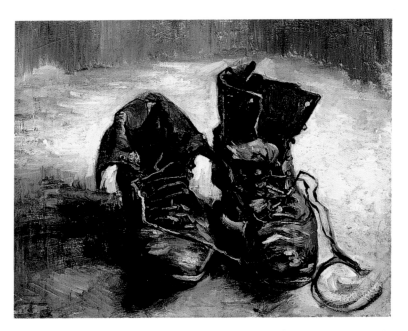

old boots

Boots with Laces, 1886, Vincent van Gogh

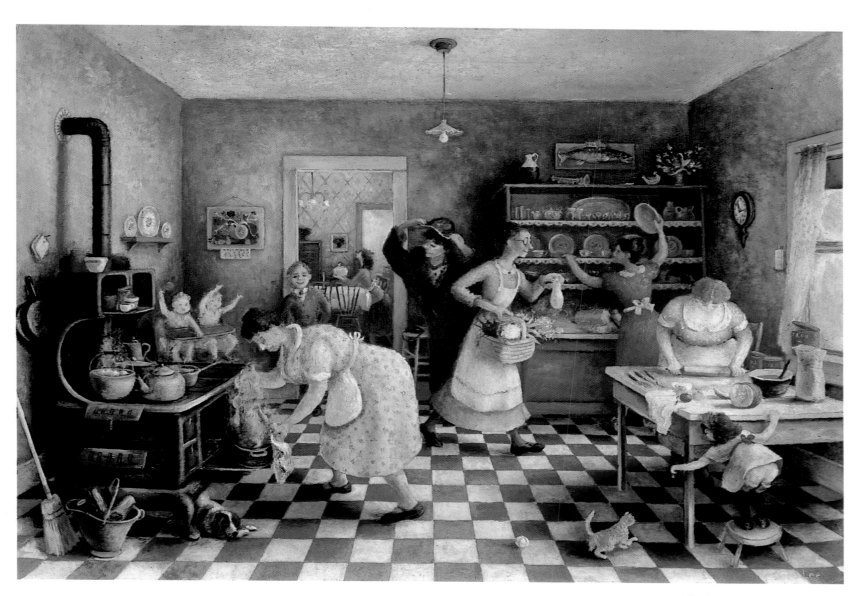

busy kitchen

Thanksgiving, c.1935, Doris Lee

How Do They Taste?

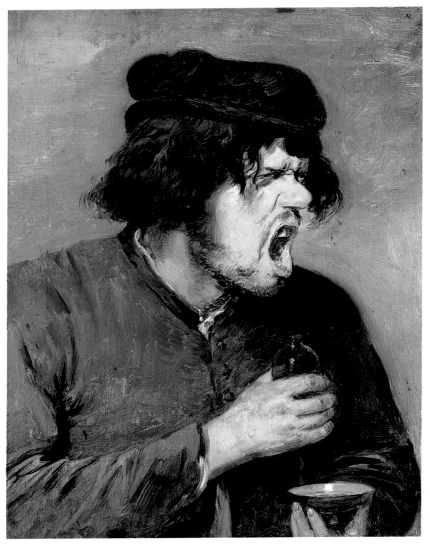

medicine

The Bitter Drink, 17th century, Adriaen Brouwer

ice cream

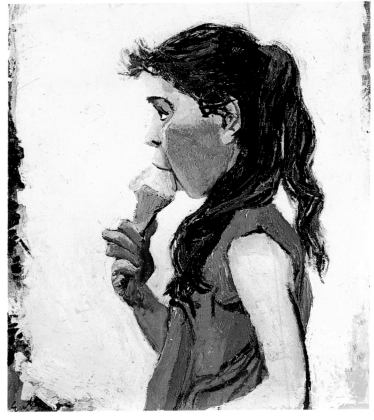

Girl Eating Ice Cream, c.1958, Renato Guttuso

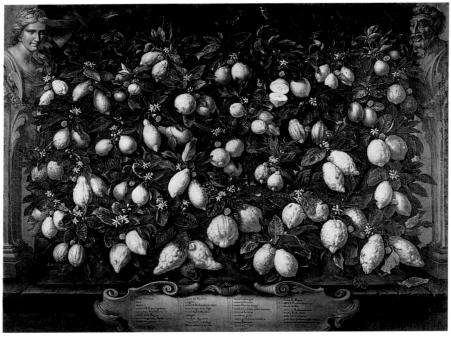

lemons

Lemons and Citrons, 1685, Bartolomeo Bimbi

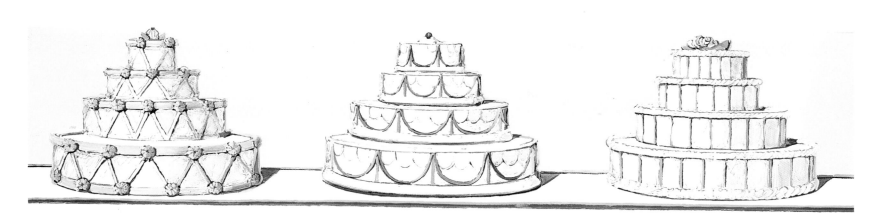

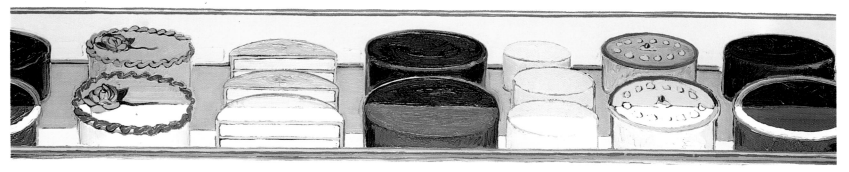

cakes

Cake Counter, 1963, Wayne Thiebaud

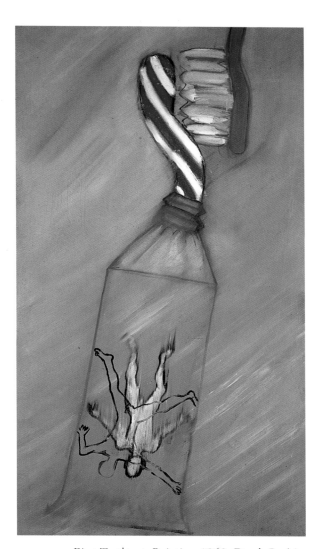

toothpaste

First Toothpaste Painting, 1962, Derek Boshier

Copy the Patterns

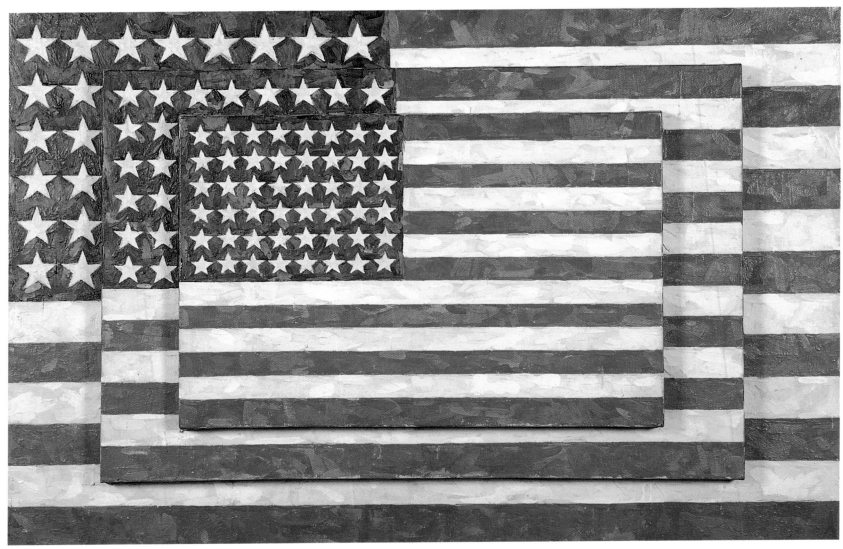

Three Flags, 1958, Jasper Johns

stars and stripes

zigzags

Got a Girl, 1960-61, Peter Blake

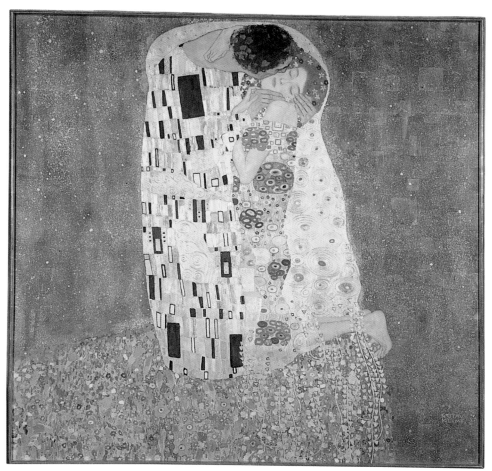

patchwork

The Kiss, 1907-08, Gustav Klimt

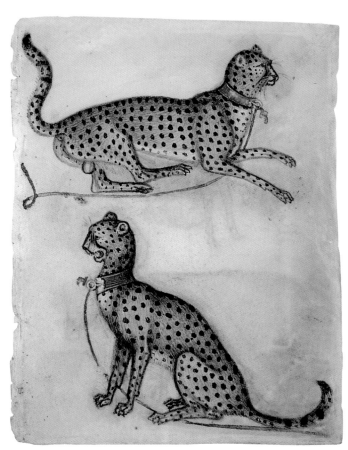

spots

Two Cheetahs, c.1400, Italian

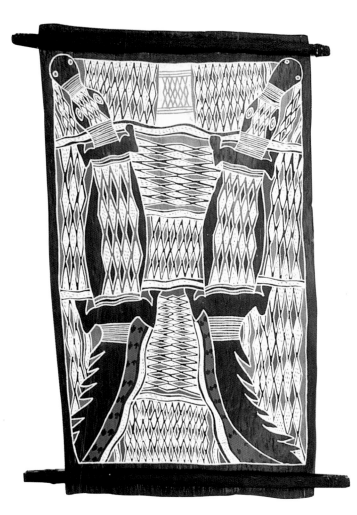

diamonds

Baru the Ancestral Crocodile, 20th century, Birrpunu Mununggurr

Touch and Feel

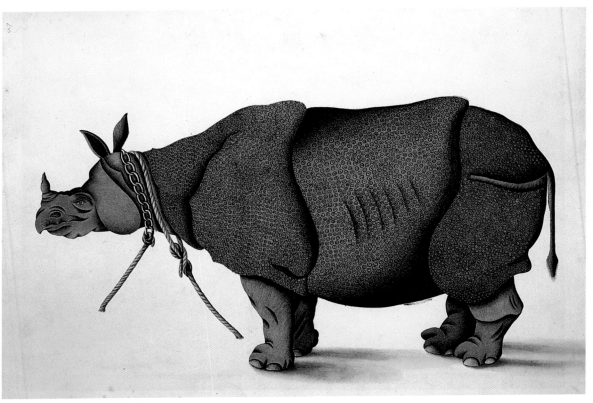

Indian Rhinoceros, 18th century, Indian

leathery rhino

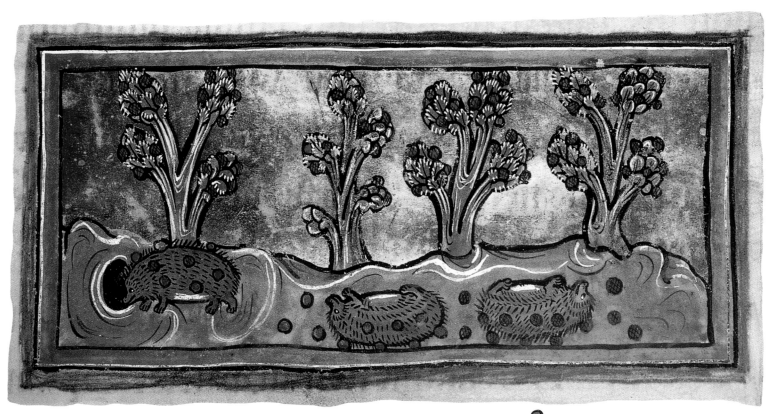

prickly hedgehogs

Hedgehogs, c.1230, from an English manuscript

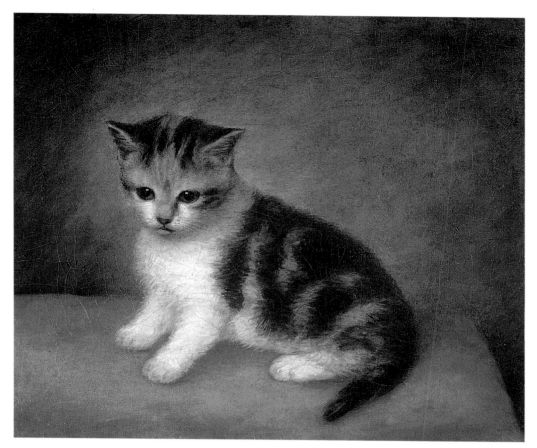

furry kitten

Miss Ann White's Kitten, 1790, George Stubbs

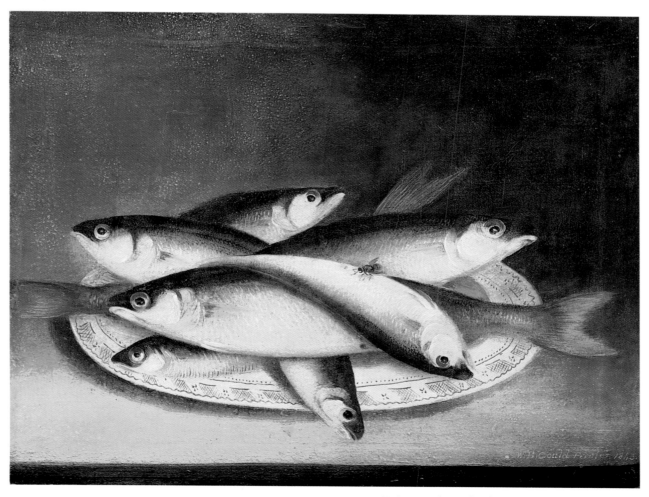

slimy fish

Fish on a Blue and White Plate, 1845, W. B. Gould

Match the Animals

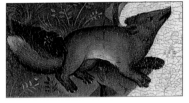
fox

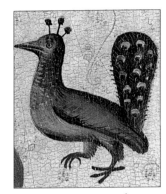
peacock

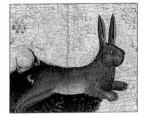
hare

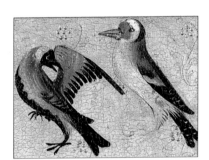
birds

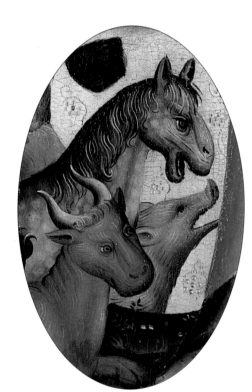
horse, pig,
and cow

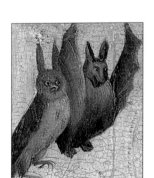
bats

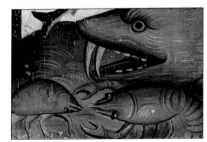
shark, lobster,
and crab

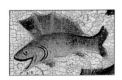
fish

rooster

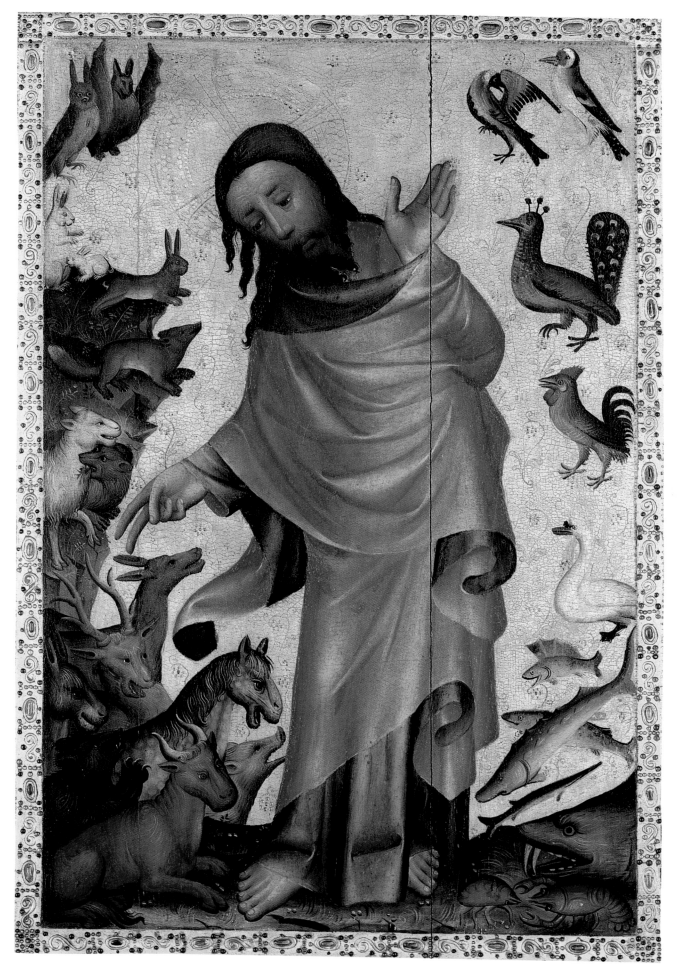

Creation of the Animals, c.1380, Master Bertram

Crazy Creatures

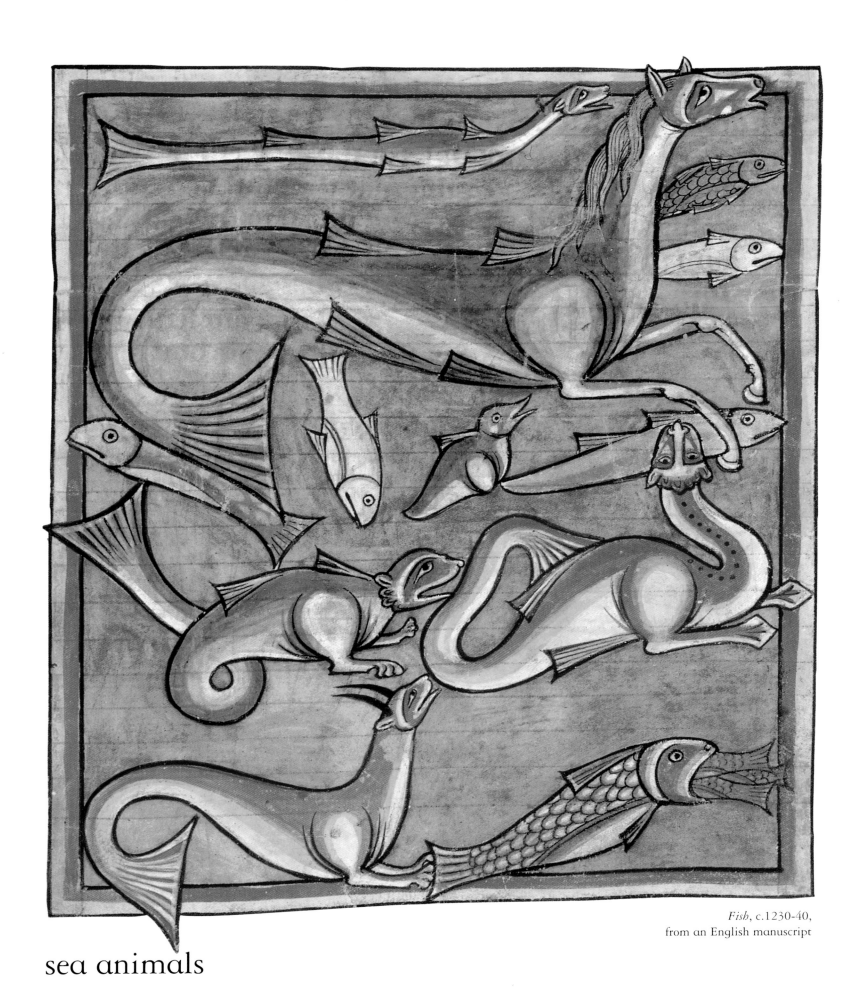

Fish, c.1230-40,
from an English manuscript

sea animals

snake

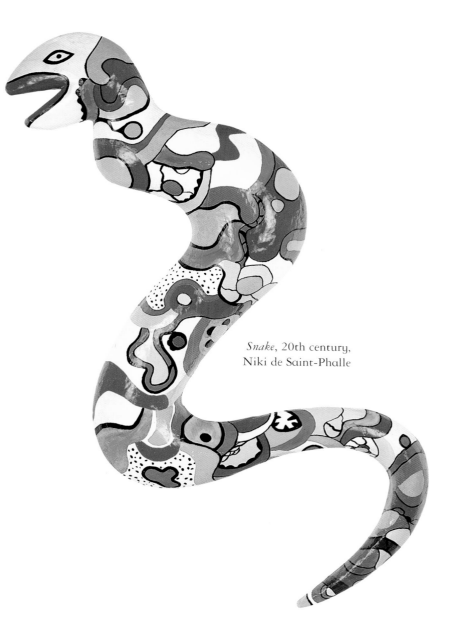

Snake, 20th century,
Niki de Saint-Phalle

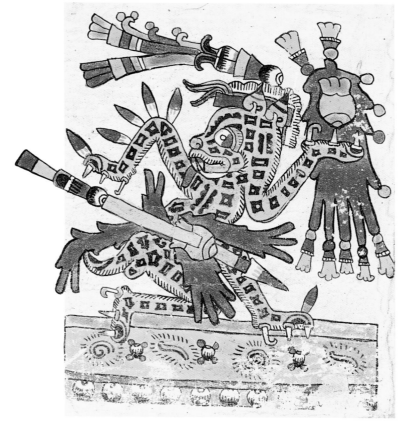

jaguar

Jaguar, c.1300-1500,
Aztec book painting

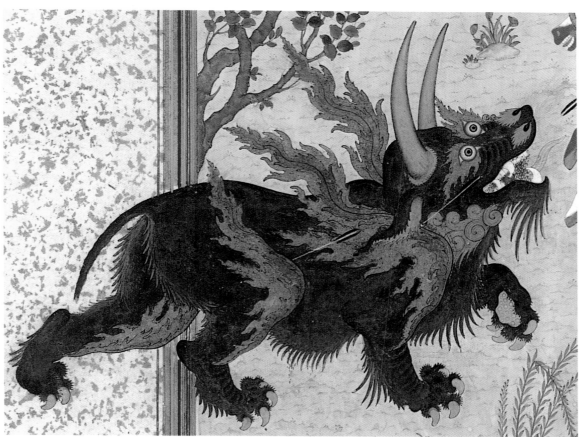

rhino wolf

Bahram Gur Slays the Rhino Wolf (detail), c.1530-35,
from an Iranian manuscript

Crazy Colors

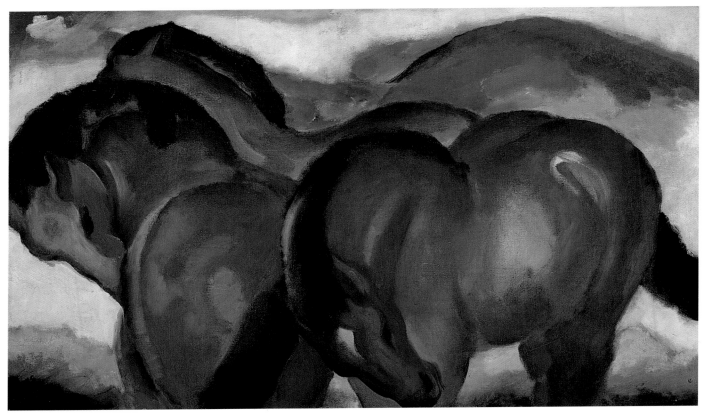

The Little Blue Horses, 1911, Franz Marc

blue horses

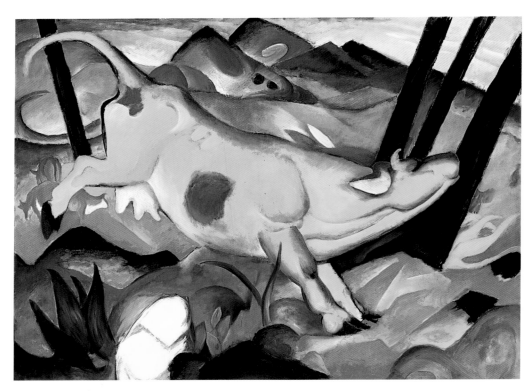

yellow

cow

The Yellow Cow, 1911, Franz Marc

multicolored face

Woman Meditating, c.1912, Alexei von Jawlensky

Make Up a Story

The girl who turned into a tree

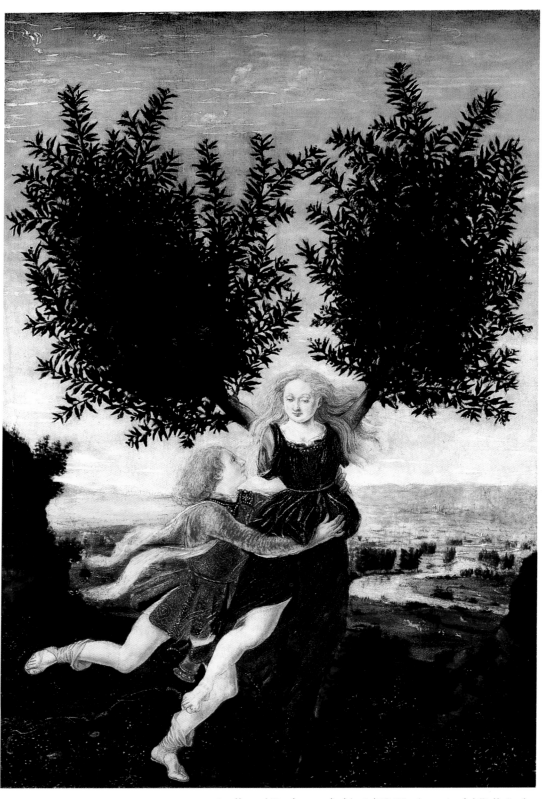

Apollo and Daphne, probably 1470-80, Antonio del Pollaiuolo

The bare-legged soldier

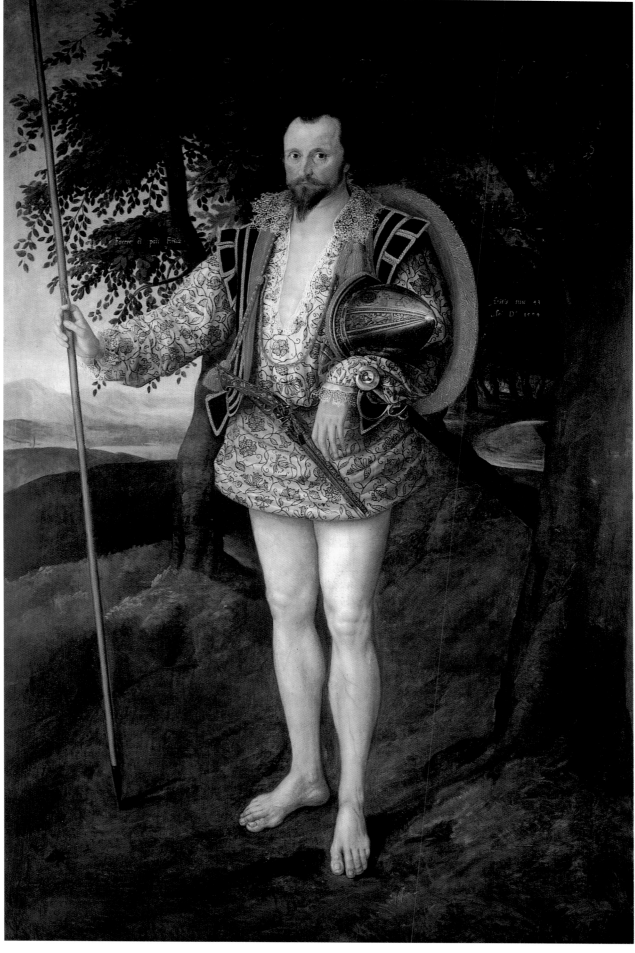

Captain Thomas Lee, 1594, Marcus Gheeraerts the Younger

The original stories of these pictures can be found on page 45.

Spot the Difference

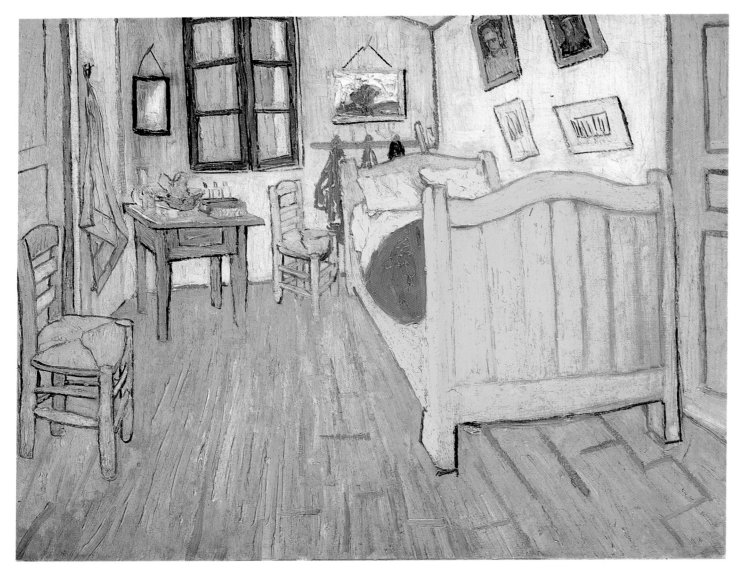

Vincent's Bedroom in Arles, 1888, Vincent van Gogh

old bedroom

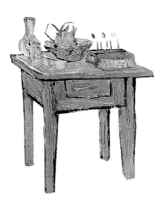

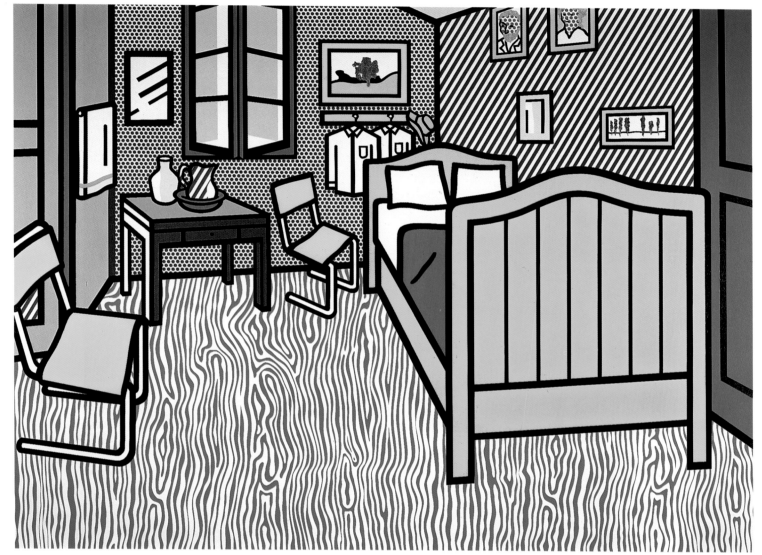

new bedroom

Bedroom at Arles, 1992, Roy Lichtenstein

What Will We Do Next?

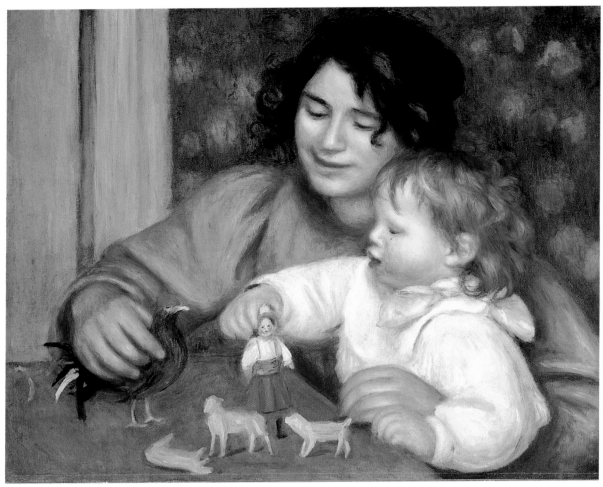

play with toys

Child with Toys – Gabrielle and the Artist's Son, Jean,
c.1894, Auguste Renoir

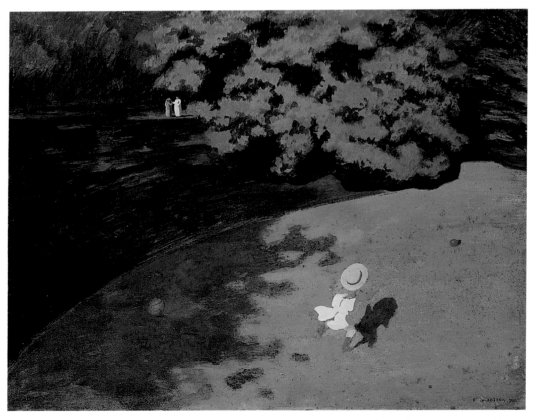

run in the park

The Ball, 1899, Félix Vallotton

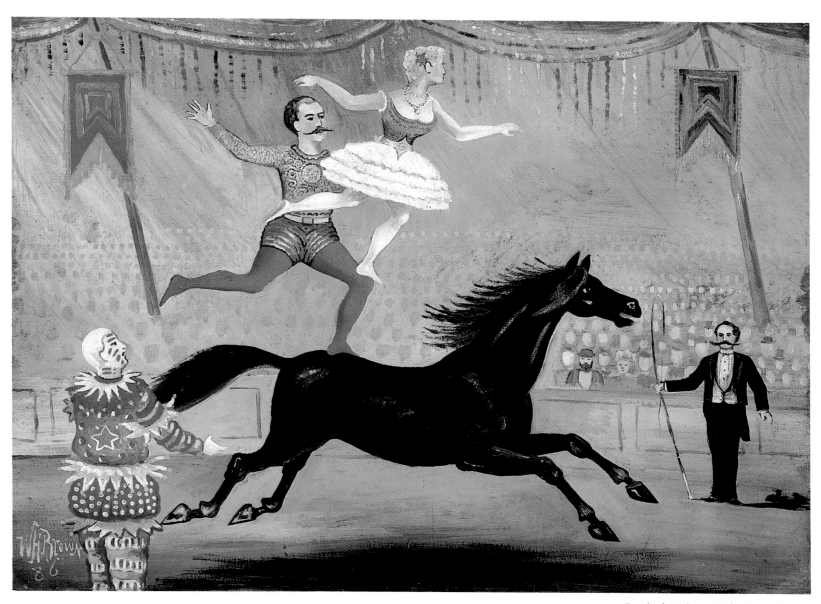

go to the circus

Bareback Riders, 1886, W. H. Brown

Picture List

All measurements listed height by width.

Let's Play

10: *Children's Games*, 1560
Pieter Bruegel the Elder, b.1525/30, d.1569,
Netherlandish
oil on wood
46 1/2 x 63 3/8 in (118 x 161 cm)
Kunsthistorisches Museum, Vienna

11: *Children's Games*, c.1868-1912
Japanese
untreated crepon print from wood blocks
143 3/4 x 102 3/8 in (365 x 260 cm)
Van Gogh Museum, Amsterdam

All Dressed Up

12: *The White Cloud, Head Chief of the Iowas*, 1844/45
George Catlin, 1796-1872, American
oil on canvas
28 x 22 7/8 in (71 x 58 cm)
National Gallery of Art, Washington, D.C.
Paul Mellon Collection

12: *Elizabeth I*, c.1569
Unknown artist
oil on wood
50 x 39 1/4 in (127.3 x 99.7 cm)
National Portrait Gallery, London

12: *Two Knights Armed for the Joust*, after 1561
Manuscript page from an illustrated
tournament book, German
pen and wash on paper
9 7/8 x 13 5/8 in (25.1 x 34.62 cm)
Metropolitan Museum of Art, New York
The Thomas J. Watson Library

13: *Soldiers of the Tenth Light Dragoons*, 1793
George Stubbs, 1724-1806, British
oil on canvas
40 1/4 x 50 3/8 in (102.2 x 127.9 cm)
Royal Collection, H.M. Queen Elizabeth II

13: *Shepherd Girl (Little Bo-Peep)*, c.1778
George Romney, 1734-1802, British
oil on canvas
46 1/2 x 35 1/2 in (118.1 x 90.2 cm)
Philadelphia Museum of Art
The John Howard McFadden Collection

13: *The White Pierrot*, 1905
Auguste Renoir, 1841-1919, French
oil on canvas
32 x 24 1/2 in (81.3 x 62.2 cm)
Detroit Institute of Arts
Bequest of Robert H. Tannahill

Where Will We Live?

14: *Warwick Castle: The East Front*, 1740s
Canaletto, 1697-1768, Italian
oil on canvas
28 3/4 x 48 in (73 x 122 cm)
Birmingham Museums and Art Gallery

14: *The Farm*, 1921-22
Joan Miró, 1893-1983, Spanish
oil on canvas
48 3/4 x 55 5/8 in (123.8 x 141.3 cm)
National Gallery of Art, Washington, D.C.
Gift of Mary Hemingway

15: *Study for Cinematic Mural*, Study I, 1939-40
Fernand Léger, 1881-1955, French
gouache, brush, pen and ink, and pencil on cardboard
20 x 16 in (50.7 x 40.5 cm)
Museum of Modern Art, New York

Let's Pretend

16: *The Kabuki Actor Nakamura Shikan II*, 1835
Shunbaisai Hokuei, active c.1824-37, Japanese
color print from woodblocks
approx. 15 x 10 in (38 x 25.5 cm)
Victoria and Albert Museum, London

16: *Surprised by the Storm*, 1886
Ferdinand Hodler, 1853-1918, Swiss
oil on canvas
39 3/8 x 51 1/8 in (100 x 130 cm)
Museum Oskar Reinhart am Stadtgarten, Winterthur

17: *Women Ironing*, c.1884
Edgar Degas, 1834-1917, French
pastel
29 7/8 x 31 7/8 in (76 x 81 cm)
Musée d'Orsay, Paris

17: *Sleeping Beauty* (detail), 19th century
Edward Frederick Brewtnall, 1846-1902, British
oil on canvas
72 x 96 in (183 x 244 cm)
Warrington Museum and Art Gallery, Cheshire
on permanent loan to Walton Hall, Warrington

Make the Faces

18: *St. John Mourning*, late 13th century
Circle of Cimabue, Italian
oil on canvas on wood
21 3/8 x 16 3/4 in (54.4 x 42.5 cm)
Städelsches Kunstinstitut, Frankfurt

18: *Portrait of Francis Ponge – Hilarious Figure*, 1947
Jean Dubuffet, 1901-1985, French
molded plaster painted in oil on canvas
24 x 18 in (61 x 46 cm)
Stedelijk Museum, Amsterdam

18: *A Kwakiutl Ceremonial Screen*, c.1935
Willie Seaweed, 1893-1967, Native North American
paint on cloth
120 x 120 in (304.8 x 304.8 cm)
Private Collection

18: *Gorgon's Head*, c.490 BC
From a red figure hydria (water container), Greek
terra-cotta
6 x 6 in (15 x 15.5 cm) (image shown)
British Museum, London

19: *Thumbing*, 1991
Gilbert and George, active since 1967, British
photopiece
66 1/2 x 56 in (169 x 142 cm)
Private Collection

Animal Noises

20: *The Cow with the Subtile Nose*, from the
Cows, Grass, Foliage series, 1954
Jean Dubuffet, 1901-1985, French
oil and enamel on canvas
35 x 45 3/4 in (88.9 x 116.1 cm)
Museum of Modern Art, New York
Benjamin Scharps and David Scharps Fund

20: *Horse Fair*, 1853
Rosa Bonheur, 1822-1899, French
oil on canvas
96 1/4 x 199 1/2 in (244.5 x 506.8 cm)
Metropolitan Museum of Art, New York
Gift of Cornelius Vanderbilt, 1887

21: *Tiger by a Torrent*, c.1795
Kishi Ganku, 1756-1838, Japanese
hanging scroll, ink and colors on silk
66 1/2 x 45 in (169 x 114.3 cm)
British Museum, London

21: *Drinking cup with owl between two olive twigs*,
4th century BC, Greek
terra-cotta
3 1/4 x 6 in (8.3 x 15.5 cm)
City of Stoke-on-Trent Museum and Art Gallery
Staffordshire Polytechnic Collection

21: *Fieldmice*, c.1600
Jacob de Gheyn II, 1565-1629, Dutch
drawing on paper
5 x 7 1/4 in (12.8 x 18.3 cm)
Rijksmuseum, Amsterdam

How Do They Smell?

22: *The Pigsty*, 1647
Paulus Potter, 1625-1654, Dutch
oil on wood
22 x 20 in (56 x 51 cm)
Musées royaux des Beaux-Arts de Belgique, Brussels

22: *The Soul of the Rose*, 1908
John William Waterhouse, 1849-1917, British
oil on canvas
34 1/4 x 23 1/4 in (88.3 x 59.1 cm)
Private Collection

22: *Boots with Laces*, 1886
Vincent van Gogh, 1853-1890, Dutch
oil on canvas
14 3/4 x 17 3/4 in (37.5 x 45 cm)
Van Gogh Museum, Amsterdam

23: *Thanksgiving*, c.1935
Doris Lee, 1905-1983, American
oil on canvas
28 1/8 x 40 in (71.4 x 101.6 cm)
Art Institute of Chicago
Mr. and Mrs. Frank G. Logan Prize Fund

How Do They Taste?

24: *The Bitter Drink*, 17th century
Adriaen Brouwer, b.1605/06, d.1638, Flemish
oil on wood
18 3/4 x 14 in (47.5 x 35.5 cm)
Städelsches Kunstinstitut, Frankfurt

24: *Girl Eating Ice Cream*, c.1958
Renato Guttuso, 1911-1987, Italian
oil on canvas
28 x 23 5/8 in (71 x 60 cm)
Private Collection

24: *Lemons and Citrons*, 1685
Bartolomeo Bimbi, 1648-1730, Italian
oil on canvas
Galleria Palatina, Palazzo Pitti, Florence

25: *Cake Counter*, 1963
Wayne Thiebaud, b.1920, American
oil on canvas
60 x 72 in (152.4 x 183 cm)
Museum Ludwig, Cologne
Ludwig Donation

25: *First Toothpaste Painting*, 1962
Derek Boshier, b.1937, British
oil on canvas
54 x 30 in (137.4 x 76.5 cm)
City Museum and Mappin Art Gallery, Sheffield

Copy the Patterns

26: *Three Flags*, 1958
Jasper Johns, b.1930, American
encaustic on canvas
30 7/8 x 45 1/2 x 5 in (78.4 x 115.6 x 12.7 cm)
Whitney Museum of American Art, New York
50th Anniversary Gift of the Gilman Foundation, Inc.,
The Lauder Foundation, A. Alfred Taubman, an
anonymous donor, and purchase

26: *Got a Girl*, 1960-61
Peter Blake, b.1932, British
oil, wood, photo-collage, and record on hardboard
36 1/4 x 60 1/4 in (92 x 153 cm)
Whitworth Art Gallery, University of Manchester

27: *The Kiss*, 1907-08
Gustav Klimt, 1862-1918, Austrian
oil on canvas
70 7/8 x 70 7/8 in (180 x 180 cm)
Österreichische Galerie, Vienna

27: *Two Cheetahs*, c.1400
Italian
brush and body-colors on parchment
6 1/8 x 4 1/2 in (15.6 x 11.5 cm)
British Museum, London

27: *Baru the Ancestral Crocodile, at his site in Gumatj country with
the clan diamond design representing fire*, 20th century
Birrpunu Mununggurr, Aboriginal artist of the Gumatj Clan
natural pigments on bark
34 1/2 x 19 in (88 x 48.5 cm)
Museum of Mankind, London

Touch and Feel

28: *Indian Rhinoceros*, 18th century
Indian, a drawing from Marquess Wellesley's
Collection of Natural History Drawings
11 3/8 x 16 1/2 in (29 x 42 cm)
British Library, London

28: *Hedgehogs*, c.1230
Illustration from a medieval bestiary, English
Royal MS 12 FXIII f.45
vellum
11 3/4 x 8 3/8 in (29.8 x 21.4 cm) (page size)
approx. 2 1/4 x 4 1/4 in (5.5 x 11 cm) (image size)
British Library, London

29: *Miss Ann White's Kitten*, 1790
George Stubbs, 1724-1806, British
oil on canvas
10 x 12 in (25.5 x 30.5 cm)
Private Collection

29: *Fish on a Blue and White Plate*, 1845
W. B. Gould, 1803-1853, Australian
oil on canvas
8 x 12 in (20.3 x 30.5 cm)
National Gallery of Australia, Canberra

Match the Animals

31: *Creation of the Animals*, c.1380
a scene from the Grabower Altarpiece
Master Bertram, active 1367-1410, German
tempera on wood
31 1/2 x 20 in (80 x 51 cm)
Kunsthalle, Hamburg

Crazy Creatures

32: *Fish*, c.1230-40
Illustration from a medieval bestiary, English
MS Harley 4751, f.68
vellum
12 1/8 x 9 1/4 in (30.7 x 23.5 cm) (page size)
approx. 7 x 6 in (18 x 15.5 cm) (image size)
British Library, London

33: *Snake*, 20th century
Niki de Saint-Phalle, b.1930, French
painted polyester
59 in (150 cm) (height)
Private Collection

33: *Jaguar*, detail from the Codex Cospi,
one of the sacred painted books
of ancient Mexico, c.1300-1500, Aztec
natural pigments on deerskin
approx. 7 x 7 in (18 x 18 cm) (section),
143 in (364 cm) (total length)
Bibloteca Universitaria, Bologna

33: *Bahram Gur Slays the Rhino Wolf* (detail), c.1530-35
Illustration from the Shahnama (Book of Kings), Iranian
colors, ink, silver, and gold on paper
11 1/4 x 7 3/8 in (28.5 x 18.7 cm)
Metropolitan Museum of Art, New York
Gift of Arthur A. Houghton, Jr., 1970

Crazy Colors

34: *The Little Blue Horses*, 1911
Franz Marc, 1880-1916, German
oil on canvas
24 x 39 3/4 in (61 x 101 cm)
Staatsgalerie, Stuttgart
Lutze Collection

34: *The Yellow Cow*, 1911
Franz Marc, 1880-1916, German
oil on canvas
55 1/8 x 74 3/4 in (140 x 190 cm)
Solomon R. Guggenheim Museum, New York

35: *Woman Meditating*, c.1912
Alexei von Jawlensky, 1864-1941, Russian
oil on board
21 1/4 x 19 1/8 in (54 x 48.5 cm)
Private Collection

Make Up a Story

36: *Apollo and Daphne*, probably 1470-80
Antonio del Pollaiuolo, c.1432-1498, Italian
oil on wood
11 5/8 x 7 7/8 in (29.5 x 20 cm)
National Gallery, London

37: *Captain Thomas Lee*, 1594
Marcus Gheeraerts the Younger, b.1561/62, d.1636,
Flemish
oil on canvas
90 3/4 x 59 1/2 in (230.5 x 151 cm)
Tate Gallery, London

Spot the Difference

38: *Vincent's Bedroom in Arles*, 1888
Vincent van Gogh, 1853-1890, Dutch
oil on canvas
28 3/8 x 35 3/8 in (72 x 90 cm)
Van Gogh Museum, Amsterdam

39: *Bedroom at Arles*, 1992
Roy Lichtenstein, b.1923, American
oil and magna on canvas
126 x 165 1/2 in (320 x 420.4 cm)
Private Collection

What Will We Do Next?

40: *Child with Toys – Gabrielle and the
Artist's Son, Jean*, c.1894
Auguste Renoir, 1841-1919, French
oil on canvas
21 3/8 x 25 3/4 in (54.3 x 65.4 cm)
National Gallery of Art, Washington, D.C.
Collection of Mr. and Mrs. Paul Mellon

40: *The Ball*, 1899
Félix Vallotton, 1865-1925, Swiss
oil on card on wood
18 7/8 x 24 in (48 x 61 cm)
Musée d'Orsay, Paris

41: *Bareback Riders*, 1886
W. H. Brown, active 1886-87, American
oil on cardboard mounted on wood
18 1/2 x 24 1/2 in (47 x 62.2 cm)
National Gallery of Art, Washington, D.C.
Gift of Edgar William and Bernice Chrysler Garbisch

Front Cover

From top left; clockwise:
The White Cloud, Head Chief of the Iowas (detail), page 12
Miss Ann White's Kitten (detail), page 29
Children's Games (detail), page 11
Hedgehogs (detail), page 28
Bareback Riders (detail), page 41
Child with Toys - Gabrielle and the Artist's Son, Jean (detail), page 40
Gorgon's Head, page 18
Fish, page 32

Front Flap

Miss Ann White's Kitten (detail), page 29
Two Cheetahs (detail), page 27

Back Cover

From top left; clockwise:
Soldiers of the Tenth Light Dragoons (detail), page 13
Miss Ann White's Kitten (detail), page 29
Children's Games (detail), page 11
Shepherd Girl (detail), page 13
The White Pierrot (detail), page 13

Title Page

Bahram Gur Slays the Rhino Wolf, page 33
Miss Ann White's Kitten (detail), page 29
Hedgehogs, page 28

Contents

Fieldmice (detail), page 21
Two Knights Armed for the Joust, page 12
Women Ironing (detail), page 17
Fieldmice, page 21
The Bitter Drink (detail), page 24
Two Cheetahs (detail), page 27
The Little Blue Horses, page 34
Apollo and Daphne (detail), page 36
Bareback Riders, page 41

Note to Parents and Teachers

The Kabuki Actor Nakamura Shikan II (detail), page 16
Gorgon's Head, page 18
Thanksgiving, page 23
Vincent's Bedroom in Arles, page 38
The Soul of the Rose, page 22
Drinking cup with owl between two olive twigs, page 21
Horse Fair, page 20

The author and publisher would like to thank the museums, galleries, and collectors listed for their kind permission to reproduce the pictures in this book.

Make Up a Story

These are the stories of the paintings on pages 36 and 37.

Apollo and Daphne

There are many different versions of the story of Apollo and Daphne. This version is based on the story accompanying the painting in the National Gallery.

Cupid, the god of love, fired one of his golden arrows at the sun god, Apollo. This made Apollo fall desperately in love with a young girl named Daphne. But one day Apollo annoyed Cupid by questioning his skill with a bow and arrow. Cupid was determined to seek revenge.

He fired a blunted arrow at Daphne, which made her dislike Apollo. She ran away from him through a forest and down toward a river. Just as Apollo caught up with her, she cried out to her father, the river god, for help. Her father heard her and turned her into a beautiful laurel tree so Apollo could never catch her.

Captain Thomas Lee

Thomas Lee was a captain in the army of Queen Elizabeth I of England. He was a brave and ambitious man, but often in trouble. In 1594 he had this unusual portrait painted and sent to the queen.

The painting was full of messages to her. There is some Latin writing in the oak tree that means "to act and suffer bravely." This was to remind the queen of his own bravery and suffering. His beautiful shirt and finely engraved helmet and pistol show that he was a man of noble birth. But his bare legs, like those of a poor Irish foot soldier, seem to suggest that he could not afford a pair of pants.

Captain Lee hoped the queen would reward him for the time he had spent fighting in the army. He wanted money, land, and power. But his scheme failed. Seven years later he was executed for plotting against the queen.

Acknowledgments

Key: l=left, r=right, t=top, c=center, a=above, b=below

The author and publisher would like to thank the following for their permission to reproduce the photographs:

front cover
tl: © 1996 Board of Trustees, National Gallery of Art, Washington
cla: © By permission of The British Library
cl: Michael Holford
tc: Roy Miles Gallery, 29 Bruton Street, London W1/Bridgeman Art Library, London
bc: © 1996 Board of Trustees, National Gallery of Art, Washington
tr: © Van Gogh Museum (Vincent van Gogh Foundation), Amsterdam
cra: © By permission of The British Library
cr: © 1996 Board of Trustees, National Gallery of Art, Washington

front flap
tc: Roy Miles Gallery, 29 Bruton Street, London W1/Bridgeman Art Library, London
bc: © British Museum

back cover
tl: © Her Majesty Queen Elizabeth II, The Royal Collection
bl: © 1986 The Detroit Institute of Arts
tc: Roy Miles Gallery, 29 Bruton Street, London W1/Bridgeman Art Library, London
tr: © Van Gogh Museum (Vincent van Gogh Foundation), Amsterdam
br: © Philadelphia Museum of Art

4: © The Metropolitan Museum of Art, New York
5bc: © By permission of The British Library
6t: © 1991 The Metropolitan Museum of Art, New York
6bl: © Rijksmuseum, Amsterdam
6br: © photo RMN
7tl: © Rijksmuseum, Amsterdam
7tr: © Staatsgalerie, Stuttgart
7cl: © Artothek
7cr: © Reproduced by courtesy of the Trustees, The National Gallery, London
7bl: © British Museum
7br: © 1996 Board of Trustees, National Gallery of Art, Washington

8tl: © By courtesy of the Board of Trustees of The Victoria & Albert Museum
8cr: Michael Holford
8bl: © 1995, The Art Institute of Chicago. All rights reserved.
9tr: © Van Gogh Museum (Vincent van Gogh Foundation), Amsterdam
9cl: Roy Miles Gallery, 29 Bruton Street, London W1/Bridgeman Art Library, London
9cr: et archive
9bl: © The Metropolitan Museum of Art, New York
10: © Kunsthistorisches Museum, Vienna
11: © Van Gogh Museum (Vincent van Gogh Foundation), Amsterdam
12tl: © 1996 Board of Trustees, National Gallery of Art, Washington
12tr: By courtesy of The National Portrait Gallery, London
12b: © 1991 The Metropolitan Museum of Art, New York
13t: © Her Majesty Queen Elizabeth II, The Royal Collection
13bl: © Philadelphia Museum of Art
13br: © 1986 The Detroit Institute of Arts
14t: © Birmingham Museums and Art Gallery
14b: © ADAGP, Paris and DACS, London 1996 /Board of Trustees, National Gallery of Art, Washington
15: © SPADEM/ADAGP, Paris and DACS, London 1996/1995 The Museum of Modern Art, New York
16t: © By courtesy of the Board of Trustees of The Victoria & Albert Museum
16b: © Museum Oskar Reinhart Am Stadtgarten
17t: © photo RMN
17b: Warrington Museum & Art Gallery, Cheshire/Bridgeman Art Library, London
18trl: Ursula Edelman
18tr: © ADAGP, Paris and DACS, London 1996/Stedelijk Museum, Amsterdam
18bl: Christies, New York
18br: Michael Holford
19: courtesy Anthony d' Offay Gallery, London
20t: © ADAGP, Paris and DACS, London 1996/1995 The Museum of Modern Art, New York
20b: © 1986 The Metropolitan Museum of Art, New York
21trl: © British Museum
21cr: et archive
21b: © Rijksmuseum, Amsterdam
22tl: © Musées royaux des Beaux-Arts de Belgique
22tr: Roy Miles Gallery, 29 Bruton Street, London W1/Bridgeman Art Library, London

22b: © Van Gogh Museum (Vincent van Gogh Foundation), Amsterdam
23: © 1995, The Art Institute of Chicago. All Rights Reserved.
24tl: Artothek
24tr: © DACS 1996/Scala
24b: Scala
25t: © Rheinisches Bildarchiv, Köln
25b: © Reproduced by permission of Sheffield Arts and Museums Department
26t: © Jasper Johns/DACS, London/VAGA, New York 1996/Whitney Museum of American Art, New York
26b: © The Whitworth Art Gallery, The University of Manchester
27t: Artothek
27bl, 27br: © British Museum
28t, 28b: © By permission of The British Library
29t: Roy Miles Gallery, 29 Bruton Street, London W1/Bridgeman Art Library, London
29b: © National Gallery of Australia, Canberra
30, 31: Elke Walford, Fotowerkstatt, Kunsthalle, Hamburg
32: © By permission of The British Library
33tr: © ADAGP, Paris and DACS, London 1996/Christies, Amsterdam
33tl: Werner Forman Archive
33br: © 1995 The Metropolitan Museum of Art, New York
34t: © Staatsgalerie, Stuttgart
34b: Artothek
35: © DACS 1996/Scala
36: © Reproduced by courtesy of the Trustees, The National Gallery, London
37: © Tate Gallery, London
38t, 38bl: © Van Gogh Museum (Vincent van Gogh Foundation), Amsterdam
39t, 39bl: © Roy Lichtenstein/DACS 1996
40t: © 1996 Board of Trustees, National Gallery of Art, Washington
40b: © photo RMN
41: © 1996 Board of Trustees, National Gallery of Art, Washington